Coloring and Crosswords™
ABC's and 123's

Coloring and Crosswords is a book series created by author Keith Hammond. Many of his books, videos, podcasts, films, and other works are available at major retailers and his website PastorKeith.org. All Rights Reserved.

LessonsForLifeBooks.com

IMPRINT | A Lessons For Life Book

Coloring and Crosswords

ABC's and 123's

© 2016 by
Keith M. Hammond
is published by
Lessons for Life Books, Inc.
St. Paul, MN 55116

No part of this book may be reproduced or utilized in any for or by any means, electronic or mechanical, including photocopying, recording, or by any information storage or retrieval system, without permission in writing from the Publisher.

Inquiries should be addressed in writing by email to:
permissionrequest@LessonsForLifeBooks.com

ISBN 13: 978-1537337432. Printed in the U.S.A.

Cover design and layout and crosswords by Keith M. Hammond.
DISCLAIMER: We claim no ownership of the Fonts used to make this material.

Coloring and Crosswords™

Coloring and Crosswords™

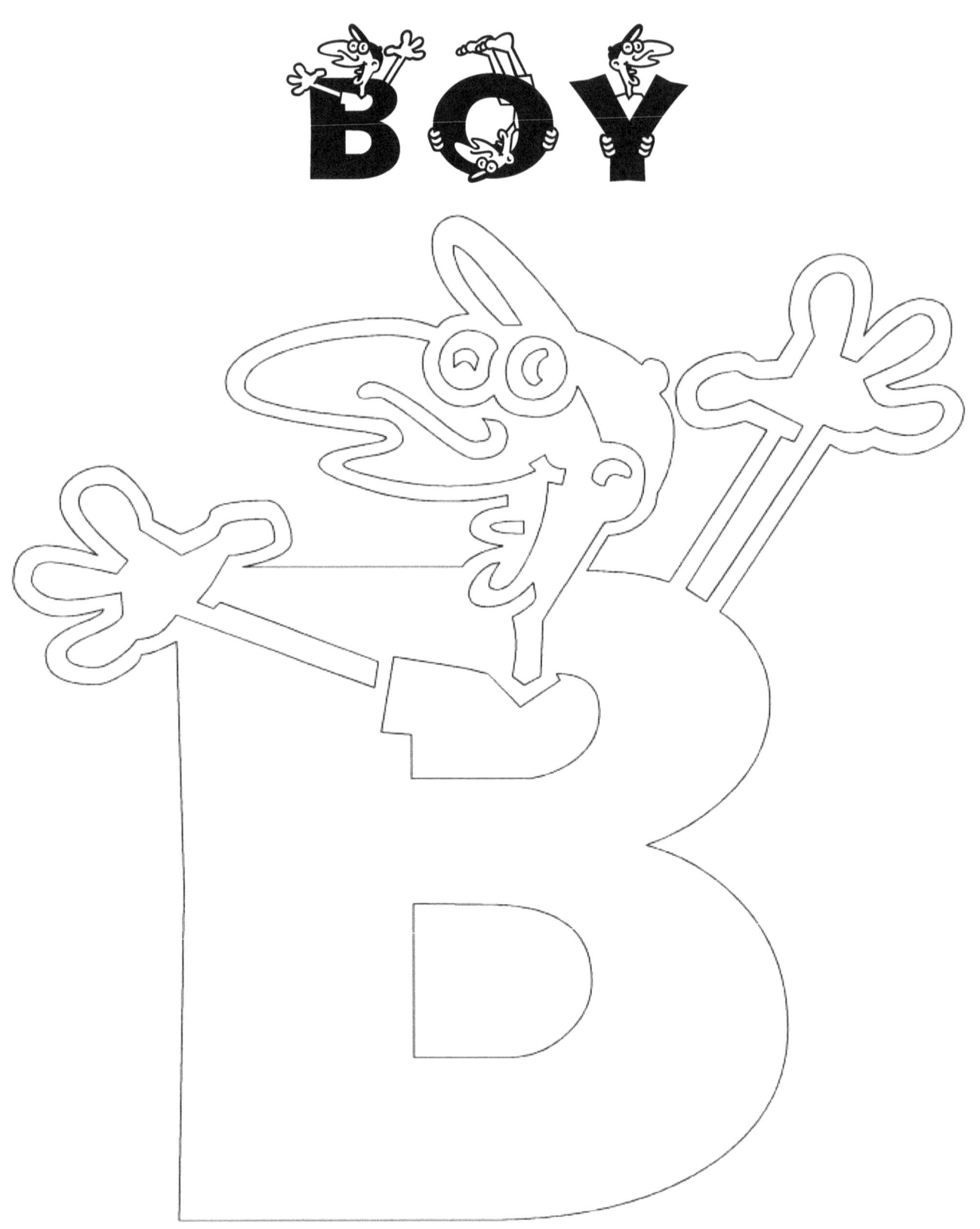

ABC's and 123's

Coloring and Crosswords™

ABC's and 123's

Coloring and Crosswords™

ABC's and 123's

Coloring and Crosswords™

ABC's and 123's

Coloring and Crosswords™

ABC's and 123's

13

Coloring and Crosswords™

ABC's and 123's

Coloring and Crosswords™

ABC's and 123's

Coloring and Crosswords™

ABC's and 123's

19

Coloring and Crosswords™

ABC's and 123's

Coloring and Crosswords™

ABC's and 123's

23

Coloring and Crosswords™

24

ABC's and 123's

ABC's and 123's

27

Coloring and Crosswords™

28

ABC's and 123's

Coloring and Crosswords™

ABC's and 123's

Coloring and Crosswords™

ABC's and 123's

Coloring and Crosswords™

ABC's and 123's

35

Coloring and Crosswords™

36

ABC's and 123's

Coloring and Crosswords™

ABC's and 123's

39

Coloring and Crosswords™

ABC's and 123's

Coloring and Crosswords™

ABC's and 123's

Coloring and Crosswords™

ABC's and 123's

Coloring and Crosswords™

46

ABC's and 123's

Coloring and Crosswords™

ABC's and 123's

49

Coloring and Crosswords™

ACROSS
1. DAY AFTER WEEKEND [ABBR]
3. THEY FLY WITHOUT WINGS
5. THEY KEEP YOUR WARM
7. IT'S AT THE BEACH

DOWN
1. WHAT WATER CAN BE
2. DIRECTION ON MAPS
4. LIGHTS IN THE SKY
6. LIGHT IN THE SKY

[Answers on last page]

THEME: OUTSIDE

ABC's and 123's

ACROSS
1. YOU DRINK OUT OF IT
3. YOU EAT ICE CREAM IN THEM
5. IN THE FRIDGE AND PANTRY
7. BOILED SCRAMBLED SUNNY SIDE

DOWN
1. YOU RELAX ON IT
2. YOU PLAY MUSIC ON IT
4. YOU COOK ON IT
6. YOU WALK AND PET IT

[Answers on last page]

THEME: INSIDE

Coloring and Crosswords™

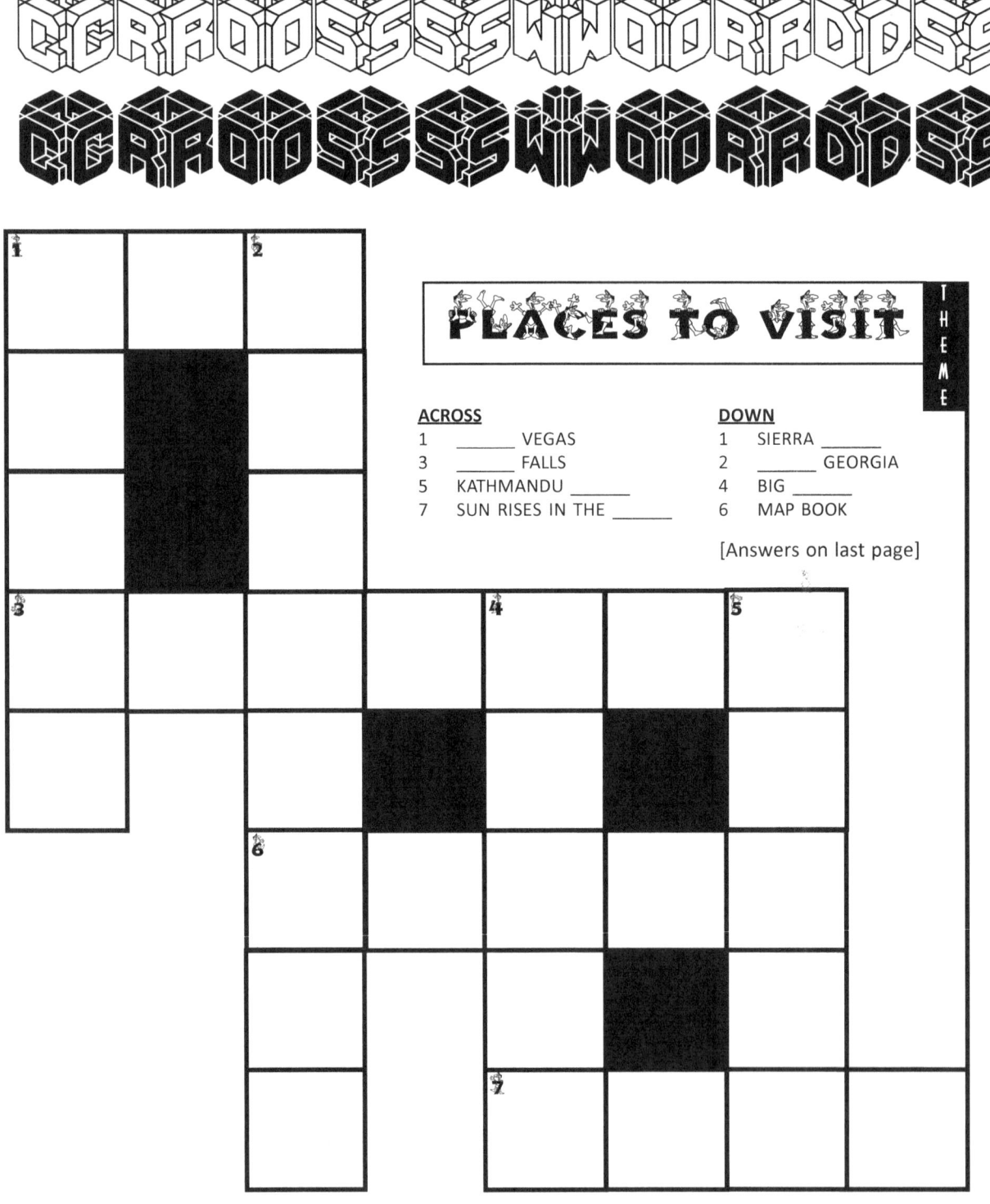

PLACES TO VISIT

ACROSS
1 _____ VEGAS
3 _____ FALLS
5 KATHMANDU _____
7 SUN RISES IN THE _____

DOWN
1 SIERRA _____
2 _____ GEORGIA
4 BIG _____
6 MAP BOOK

[Answers on last page]

ABC's and 123's

CROSSWORDS

ACROSS
1. POPULAR NUT
3. PECKING BIRD
5. LIVES IN THE OCEAN
7. BAA BAA MEAT

DOWN
1. GROUND _____
2. INKSTER
4. SHRIMP COUSIN
6. OINK OINK MEAT

[Answers on last page]

THEME: COOKING

Coloring and Crosswords™

ACROSS
1. STORM DISTRESS SIGNAL
3. THESE BLOW AROUND
5. THIS KEEPS YOUR WARM
7. CLIMATE CONDITION

DOWN
1. WINTER CONDITION
2. CLOUDLESS SKY
4. EYE OF THE _____
6. NO MOVEMENT

[Answers on last page]

THEME: WEATHER

ABC's and 123's

CROSSWORDS

ACROSS
1. MIX BLACK AND WHITE
3. THE COLOR _____
5. HAPPY EXPRESSION
7. BRIGHT AND VIVID

DOWN
1. COLOR OR SWEET FRUIT
2. SHADE OF BLUE
4. COLOR OR SOUR FRUIT
6. COLOR OR TYPE OF NUT

[Answers on last page]

THEME: COLORS

Coloring and Crosswords™

ACROSS
1. FLYING CAVE DWELLER
3. FLYING SLEIGH PULLER
5. COMPASSIONATE SHARK
7. AMERICA'S SYMBOLIC BIRD

DOWN
1. BLACK POLAR BROWN
2. MALAYAN OR ASIAN
4. MULE RELATIVE
6. FLY EATING CROAKERS [2 words]

[Answers on last page]

THEME ANIMALS

ABC's and 123's

SPACES — THEME

ACROSS
1. INTERIOR AMBIANCE
3. INTERIOR PLACES
5. DINNER SETTING
7. WARM AND INVITING

DOWN
1. ROOM OPENINGS
2. PAINT CHOICE
4. PAINT PALATE
6. LIGHT WITH A SHADE

[Answers on last page]

57

Coloring and Crosswords™

BUILDING THEME

ACROSS
1. RUBIK'S _____
3. TOP OF A CHURCH
5. CONSTRUCTION SITE
7. BLUEPRINT DRAWING

DOWN
1. NEO _____
2. OPPOSITE OF SELLER
4. OVERALL STRATEGY
6. BREAK GROUND

[Answers on last page]

ABC's and 123's

CROSSWORDS

ACROSS
1. PABLO _____
3. LEROY _____
5. _____ PAD
7. _____ ART

DOWN
1. ON WALLS AND CANVAS
2. _ _ _ _ G R A P H Y
4. FAMOUS _____
6. LEFT OR RIGHT _____

[Answers on last page]

THEME: MUSEUM

Coloring and Crosswords™

PUZZLE ANSWERS

PAGE 50

ACROSS
1. DAY AFTER WEEKEND [ABBR] — MON
3. THEY FLY WITHOUT WINGS — KITES
5. THEY KEEP YOUR WARM — HATS
7. IT'S AT THE BEACH — SAND

DOWN
1. WHAT WATER CAN BE — MURKY
2. DIRECTION ON MAPS — NORTH
4. LIGHTS IN THE SKY — STARS
6. LIGHT IN THE SKY — SUN

PAGE 51

ACROSS
1. YOU DRINK OUT OF IT — CUP
3. YOU EAT ICE CREAM IN THEM — CONES
5. IN THE FRIDGE AND PANTRY — FOOD
7. BOILED SCRAMBLED SUNNY SIDE — EGGS

DOWN
1. YOU RELAX ON IT — COUCH
2. YOU PLAY MUSIC ON IT — PIANO
4. YOU COOK ON IT — STOVE
6. YOU WALK AND PET IT — DOG

PAGE 52

ACROSS
1. _____ VEGAS — LAS
3. _____ FALLS — NIAGARA
5. KATHMANDU _____ — NEPAL
7. SUN RISES IN THE _____ — EAST

DOWN
1. SIERRA _____ — LEONE
2. _____ GEORGIA — SAVANNAH
4. BIG _____ — APPLE
6. MAP BOOK — ATLAS

PAGE 53

ACROSS
1. POPULAR NUT — CASHEW
3. PECKING BIRD — CHICKEN
5. LIVES IN THE OCEAN — FISH
7. BAA BAA MEAT — LAMB

DOWN
1. GROUND _____ — CHUCK
2. INKSTER — SQUID
4. SHRIMP COUSIN — KRILL
6. OINK OINK MEAT — HAM

PAGE 54

ACROSS
1. STORM DISTRESS SIGNAL — SOS
3. THESE BLOW AROUND — WINDS
5. THIS KEEPS YOUR WARM — COAT
7. CLIMATE CONDITION — MILD

DOWN
1. WINTER CONDITION — SNOWY
2. CLOUDLESS SKY — SUNNY
4. EYE OF THE _____ — STORM
6. NO MOVEMENT — STILL

PAGE 55

ACROSS
1. MIX BLACK AND WHITE — GRAY
3. THE COLOR _____ — PURPLE
5. HAPPY EXPRESSION — SMILE
7. BRIGHT AND VIVID — NEON

DOWN
1. COLOR OR SWEET FRUIT — GRAPE
2. SHADE OF BLUE — AZURE
4. COLOR OR SOUR FRUIT — LEMON
6. COLOR OR TYPE OF NUT — ALMOND

PAGE 56

ACROSS
1. FLYING CAVE DWELLER — BAT
3. FLYING SLEIGH PULLER — REINDEER
5. COMPASSIONATE SHARK — NURSE
7. AMERICA'S SYMBOLIC BIRD — EAGLE

DOWN
1. BLACK POLAR BROWN — BEARS
2. MALAYAN OR ASIAN — TAPIR
4. MULE RELATIVE — DONKEY
6. FLY EATING CROAKERS [2 words] — TREEFROGS

PAGE 57

ACROSS
1. INTERIOR AMBIANCE — DECOR
3. INTERIOR PLACES — ROOMS
5. DINNER SETTING — TABLE
7. WARM AND INVITING — WELCOME

DOWN
1. ROOM OPENINGS — DOORS
2. PAINT CHOICE — COLOR
4. PAINT PALATE — SWATCH
6. LIGHT WITH A SHADE — LAMP

PAGE 58

ACROSS
1. RUBIK'S _____ — CUBE
3. TOP OF A CHURCH — STEEPLE
5. CONSTRUCTION SITE — LAND
7. BLUEPRINT DRAWING — DESIGN

DOWN
1. NEO _____ — CLASSIC
2. OPPOSITE OF SELLER — BUYER
4. OVERALL STRATEGY — PLANS
6. BREAK GROUND — DIG

PAGE 59

ACROSS
1. PABLO _____ — PICASO
3. LEROY _____ — NEIMAN
5. _____ PAD — SKETCH
7. _____ ART — SAND

DOWN
1. ON WALLS AND CANVAS — PAINT
2. _____ GRAPHY — CALI
4. FAMOUS _____ — ARTIST
6. LEFT OR RIGHT _____ — HAND

www.ingramcontent.com/pod-product-compliance
Lightning Source LLC
Chambersburg PA
CBHW080545190526
45169CB00007B/2650